Seasons
for Praise

ART FOR THE SANCTUARY

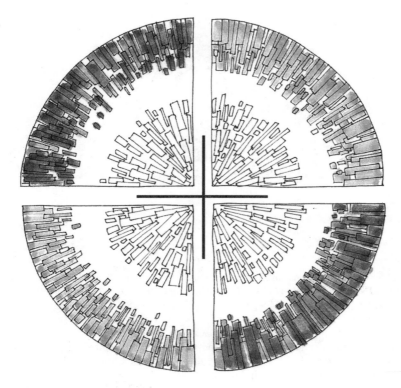

Ideas for integrating art and worship

Written by Eleanore Feucht Sudbrock
with contributions from Kenneth Manglesdorf and Sally Beck

Copyright © 2000 Creative Communications for the Parish
This edition published by Concordia Publishing House
3558 S. Jefferson Ave.
St. Louis, Missouri 63118-3968
Printed in the USA.

CONTENTS

FOREWORD

Sometimes we receive snippets of God's grace, and other times it washes over us in waves. In worship, a splash of grace can arrive with the second verse of the processional hymn, in the smile of the baby in the pew ahead of you, in the slant of sunlight through stained glass. And then sometimes it comes in a holy tidal wave when the Scripture readings, the music, the banners and paraments, the sermon, and the gathering at the table mesh into a sacred whole of time and space. This book offers suggestions for that *space* part, in the hope that what you *see* in your sanctuary is also what you get.

The many suggestions for sanctuary art found here come from several sources. Eleanore Sudbrock is a member of United Lutheran Church in Mt. Vernon, New York, and has been involved in various ministries in the New York City area. She is not a professional artist, but she is a creative worshiper with the energy to turn ideas into meaningful decoration for the sanctuary. What follows is her story—a description of projects and the creative process involved in those projects. Other ideas, interspersed with hers, come from Kenneth Mangelsdorf, pastor of St. Peter Lutheran Church, Mishawaka, Indiana. Pastor Mangelsdorf, too, has joined liturgical art forms with his worship space in beautiful ways. And a few other projects come from my drawing board at Creative Communications for the Parish. Some of the ideas are very specific and others are thought starters; some are complicated, and some are easy; some offer permanence, while others are temporary, disposable projects. All are offered with the hope that you, the creative worshiper, will use them as taking-off points for your particular worship space, adapting and changing as the Holy Spirit inspires you. Nearly all are projects for groups of various sizes—for three or for twelve or for the twenty families that might gather for a family night. And a few involve the entire congregation. The ideas are intended to create community—both in the making and in the using.

Festival days and the seasons of the church year provide this book's headings under which the ideas are grouped accordingly, but the possibilities for combining projects are limitless. Use them and let your own creative ideas enhance them. Explore the rich varieties of art materials, tools and construction aids to spur your imaginations, too. Artistic epiphanies have been known to happen in hardware stores, fabric stores, art supply places—or when peering in the dumpsters behind the stores. Be open to the Holy Spirit's prompting at any time. A display ad in the morning paper, the long shadows on your evening walk or a Sunday night symphony concert might be the impetus for a creative work in your sanctuary. May your sanctuary decoration become a harmonious and meaningful part of your worship as you gather to praise our God and King.

Sally Beck, *editor*

"There's something special going on here." That's the message when we adorn the sanctuary in special ways for different seasons. We pay attention to the many seasons and festival days of the church year in words and music, so why not in graphic arts too? This book offers a way to gather an interested small community to create an exciting place for the larger community of worshipers.

Works of art in the worship space are much more than sermon illustrations or ways of making Sundays more interesting. The purpose is to tell the story of Jesus season after season—clearly, dramatically and visually. We live in a very visual world and are called to make God's Good News visible to all in our present culture.

I have discovered that people of all ages enjoy working together to create works of art. At a church in Brooklyn, we decided to create scenery for the church hall and stage that served as Sunday school space. The curriculum began with the stories of Genesis and Exodus, so children and adults had a great time painting mountains, lakes, animals, trees, flowers and people on long sheets of kraft paper. The children were especially proud of their creation. Sitting, standing and acting in the environment they created transformed Bible story telling. It is not much of a step from Sunday school space to worship space.

Many churches already have beautiful windows, carvings or paintings that convey God's love in Christ for us. Graphic arts can give a new focal point or create a new environment that makes worship a new experience. I believe that those who come for worship are delighted by works of art and find a richer meaning in the message of the season. And those who together create the art expressions form a special sense of community.

The materials you have to work with are creative people, the richness of Scripture, worship space, the meaning of the different seasons and festivals of the church year and countless art materials.

It is interesting to gather people of different ages, cultures and experiences to work together. Something more creative happens when a group puts all of its experiences and ideas into a collaborative effort.

When your worship committee or small group gathers for the first time, you will begin to focus on a church season or festival day and the art to which that season lends itself. It is important to tell the Bible stories, themes or ideas of the season to each other. Hymns and part of the liturgy can be used as ideas, too. This is a time for meditation and inspiration. Take some quiet time for each person to get pictures and ideas in mind and then have a "free for all." (Fill in the blanks that are provided on the following pages for each season. Or, better yet, keep a running account in a loose-leaf binder of your group's brain-storming.) When everyone gets his or her own pictures, ideas or word concepts out in the middle of the group, creative energy takes over. Keep all the ideas the group loves best "in the middle" as definite possibilities. What ideas communicate emotions, create an environment, tell the story or give a message and meaning in a very graphic way? How can you show a different perspective or make new connections? Different groups can concentrate on specific Sundays or seasons—that adds to the fun and creativity.

Look at the space—walls, arches, pillars, doors, floors (yes, floor art!), light fixtures, balcony, furnishings, pews, pulpit, rafters, and don't forget the air space. How do the ideas work with the space, and can the space be the catalyst for your ideas? The size and volume of your works of art need to be in proportion to the sanctuary space. Recently, I was in a large church in upstate New York that was built in the mid-sixties. It seats 450 people, has a high ceiling, and the chancel area is unadorned tan brick with a simple wooden cross in the middle white plaster section. Two processional banners stood in the chancel. Unfortunately, they were overwhelmed by the space. To create a work of art for this space, thinking needs to be big. Something that looks huge on your dining room table work space may look small in a large chancel. Keep thinking about the possibilities.

When the group decides on an idea, it also needs to decide on work space, materials, who gathers the materials and who can oversee the work. Materials can be almost anything: fabric, paper, paint, wood, cardboard, glass, clay, what's in the attic or basement, or what's in the dumpster that you pass on your Saturday morning walk.

It is also important to remember that the process of creating the work of art is as important as the finished work. Because different members of the group will have different visions, styles and skills, allow for variety and uniqueness. You may discover hidden talents in your group that will blossom if they are encouraged.

When one of our groups made Easter butterflies to hang from the light fixtures, some adults didn't cut as carefully as others and each one had a different color sense. But when all the butterflies were floating overhead, the overall experience was grace, beauty, color and Alleluia!

Perhaps the most important thing is to decide to get started. It takes only two or three to make it a go, and you can start with any season of the church year!

No matter what season you begin with, encourage your group to try some free word associations for that season. Don't reject anything on the first round; nothing at this stage is too far out.

ADVENT

Spend some time with the Scripture readings for each of Advent's four Sundays, and read aloud some of the beautiful Advent hymns. List some of your own Advent words.

patience
surprise
fright
the unknown
hope
expectation
promise
faith
trust
grace
chosen
pregnant
stir up our hearts ... your power
prophets
turning toward God
ancient people of faith: Eve, Ruth, Hannah,
 David, Isaiah, Daniel, Mary,
 Elizabeth, Joseph, Zechariah
sandals
waiting on tiptoes
angels
dangerous mountains
crooked paths becoming straight
traveling, moving
energy
John the Baptist
O antiphons
vision of heaven
root of Jesse
Emmanuel
eyes on the prize
peace
justice
doing something astonishing

Advent colors: Advent is the season of *hope*—faithful waiting, looking forward expectantly to God and to heaven. Therefore, blue is appropriate for Advent, as well as the traditional color of purple.

11

Here is what we did one Advent at our church in Mt. Vernon, New York, on the campus of Wartburg Adult Care where the congregation and the Wartburg community worship together. The 140-year-old sanctuary is a Romanesque style with a half-round chancel and round pillars along each side of the nave. There are beautiful stained-glass windows in the chancel and along both sides of the nave and a rose window above the balcony. The windows present stories from Scripture. Above the windows, high on the clerestory walls, are frescos of the life of Luther and St. Elizabeth. The ceiling of the chancel has cherubs, traditional symbols and paintings of the four evangelists, and in the center, Jesus, risen and reigning in heaven. The church is large, seating about 250. We did not want to interfere with the beautiful existing art, so we thought of other space possibilities. I sat in church and thought about the way Advent progressed each week; that it comes little by little until we are there at the manger. I also looked around and considered the space. We could cover the first four pillars, one for each Sunday in Advent—pillar covers! I would use a medium blue color and paint figures or symbols on the fabric. Next, I found two people willing to help. (If your church doesn't have pillars, the designs, of course, could be used on large, ceiling-to-floor fabric panels instead.)

1st SUNDAY

PILLAR COVERS

We tossed around some themes that could be graphically presented. The prayers talk about "stir up," God's coming and our response. There are many persons of faith in the Advent stories. We decided on a heart for each pillar cover and the feeling of movement or stirring. The heart would be made of gold sequins, and the swirling stirring would be a generous swirl of glitter. We used spray glue, sequins, glitter and fabric paint. The first cover was a large, open hand of God with a heart in the middle of the hand and the swirl descending to us. The idea was God choosing us in grace and stirring our hearts in love and power. Elastic in the top hem allowed us to slide the cover up and over the ridge at the base of the capital to secure it and then let the fabric fall freely. This cover was put up for the first Sunday of Advent.

On the second pillar cover we put a candle with a heart in its flame and the swirl rising as prayer and commitment to God. It represented our turning toward God. This cover was put up for the second Sunday of Advent, and by then there was a rising expectation on the part of the congregation. The third cover design was an angel, and the fourth was the journey to Bethlehem. We left the pillar covers up through Christmas to make the connection, and they came down for Epiphany.

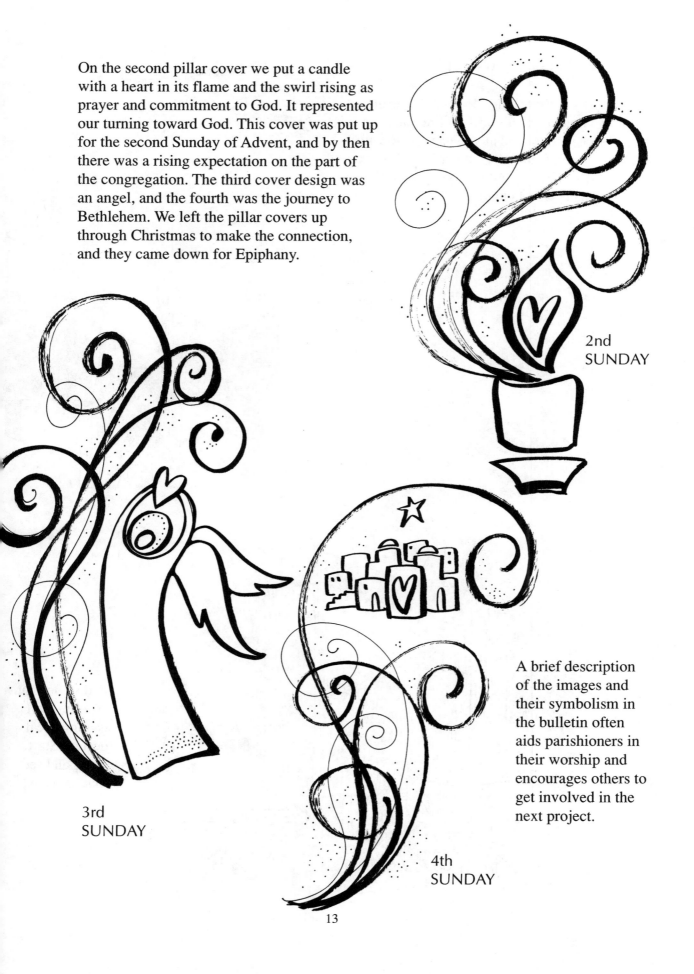

2nd
SUNDAY

3rd
SUNDAY

4th
SUNDAY

A brief description of the images and their symbolism in the bulletin often aids parishioners in their worship and encourages others to get involved in the next project.

ADVENT CANDLES

If your sanctuary does not have an Advent wreath or if you're due for a change, see what you can create with straight cuts on 1' x 2's, 2' x 2's, 2' x 4's, 4' x 4's, and a strong polyurethane wood glue.

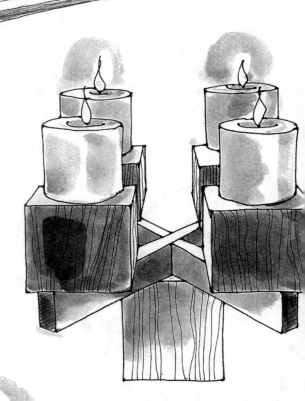

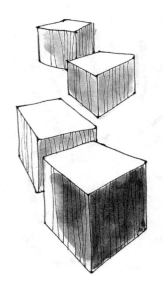

A traditional symmetrical arrangement works ...

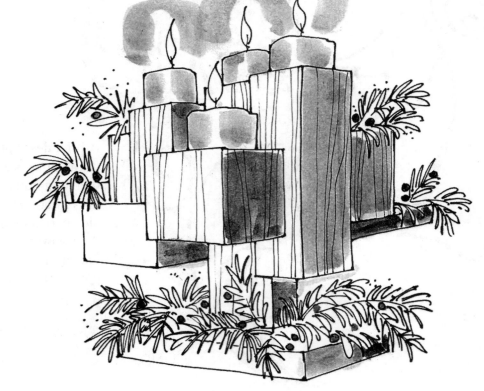

... and so does an experimental asymmetrical design. Start gluing and see what happens!

CHRISTMAS

The sounds and sights and smells of the holidays invade our senses and give our days a heightened awareness of the coming Christ Child. Christmas is the experience of God coming to be among us as one of us. The challenge is to make *God with us* a vibrant, visual experience that lays aside outside pressures and touches our hearts. Turn your awareness to the manger scene and try some free word and feeling associations:

peaceful
quiet
love
cold night
warm barn
light
angels
singing
pain and joy of childbirth
contrasts
incarnation
God as a baby
God in our world
touchable God
God held in human arms
poor and lowly
prince in a stable
holy child
farm animals
warm fur
night sky filled with music and light
smell of straw, earth
scratchy feel
baby lotion
blankets
smiling
shepherds
lambs
hills
running
announcing

What else can you add?

HEY—HAY!

Decorations for the sanctuary are sometimes not just for seeing; sometimes they invite you right into their midst. At Christmastime members of a church in Monterey, California, bring in hay and lay it in front of the altar—wide, deep and thick. They place simple and beautiful paper and cloth maché figures of Mary, Joseph, Baby Jesus and scruffy shepherds in the hay and invite worshipers to come and kneel before the Baby Jesus. A member who had immigrated from eastern Europe remembered her tradition of kneeling in the straw at the altar to receive Holy Communion on Christmas Eve. The children in the congregation remembered the sweet smell and prickly feel of hay and a baby with whom they could identify.

MACHÉ CRECHE

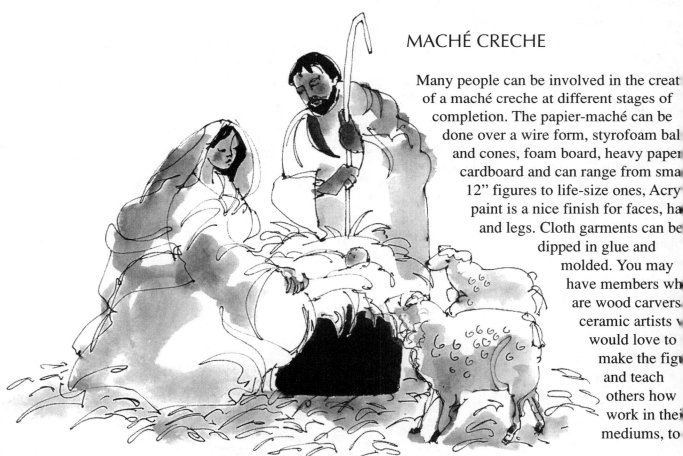

Many people can be involved in the creat of a maché creche at different stages of completion. The papier-maché can be done over a wire form, styrofoam bal and cones, foam board, heavy paper cardboard and can range from sma 12" figures to life-size ones, Acry paint is a nice finish for faces, ha and legs. Cloth garments can be dipped in glue and molded. You may have members wh are wood carvers ceramic artists v would love to make the figu and teach others how work in thei mediums, to

HEAVENLY HOST

If your chancel has a large air space above the altar, think of ways to fill it with a host of angels. You could have glitter-covered angels or block print angels on a large background fabric, or translucent angels painted on organdy or nylon organza, or large numbers of foil angels hanging on fishing line from overhead lights or beams. See the section for St. Michael and All Angels Day, page 55, for construction suggestions for the white-on-white fabric hanging pictured here. Cut these angel shapes from white nylon fabric, attach them with a running stitch to background panels of nylon organza and embellish with white acrylic paint. Allow the pieces to overlap (as pictured) for lots of variation in translucence. The angels bestow a subtle presence upon your Christmas worship.

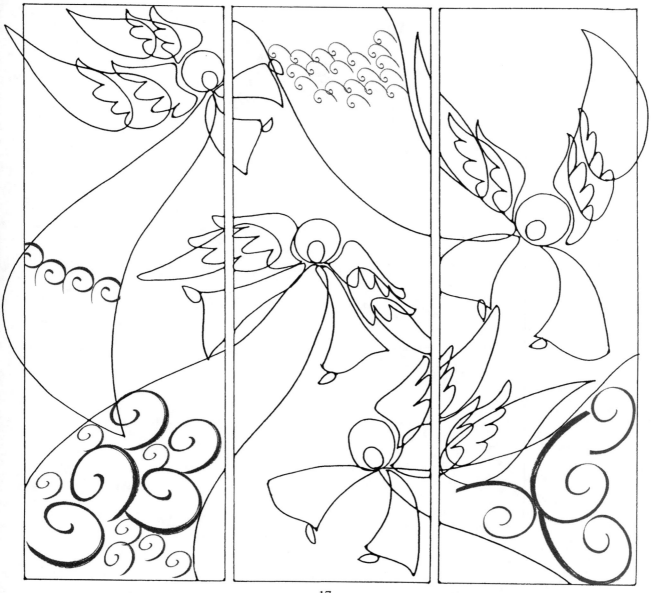

EPIPHANY

Epiphany, the season of light, pulls the curtain aside so God is in full view. God is the Light shining on and in us, shining on ahead of us and leading us to the mountaintop of faith. The readings for each week reveal God in a different way. Epiphany also brings the message of God's Son to people of all nations and all sectors of the world. Epiphany is about God going out to the people and people coming in to God, to worship Christ and live in his kingdom. What images come to mind?

seeing
bright light
colors of the spectrum
star
wise persons or scientists from afar
many nations
different cultures
worship
exotic gifts, wealth
generosity
exotic clothing
crowns
giving
adoration, bowing
a long journey
camels, desert
maps
great joy
revelation
Aha!
determination
warning
searching/following
amazement
voice of God
water
baptism
Spirit, dove
anointed
grace and forgiveness
power over evil
mission
transfiguration
lambent, luminous
halo, aura
transformation
"getting it," catching on

RAINBOW RIBBONS

Our group of sanctuary art designers had grown to three mothers of the first communion class children, and now we would focus on the Epiphany season. We decided to put together the ideas of gifts, celebration and the colors of the people of God. Our way of expressing that was to purchase spools of 1 1/2"-wide satin ribbon (polyester will do, too) to make festive ribbon decorations for the end of each pew. In addition, we replaced the usual pulpit and lectern parament hangings with rainbows of ribbons. The ribbons were all the colors of the spectrum repeated across the bookstand and extended the length of the pulpit and the lectern. The pew decorations were 16" lengths of each color tied together with curling ribbon. When people arrived, they asked, "What's the celebration?" That is exactly what we wanted them to feel.

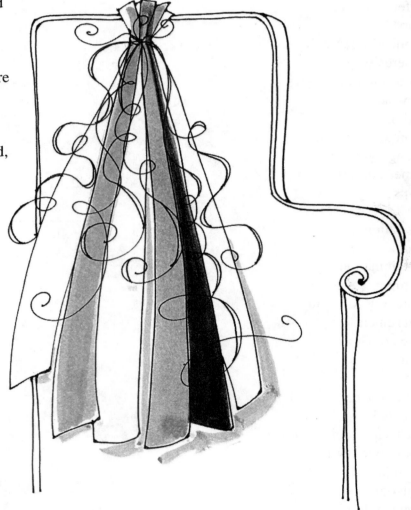

KING CUTOUTS

An important Latino festival, *El Dia de Los Reyes*, focuses on the coming of the wise men from afar, and a procession of large cutouts can highlight this. Pillars, side walls and ends of the pews make great places for the wise men. If you use foam core, they can be freestanding, and since foam core is available in sheets as large as 4" x 8", your figures can be eight feet tall! A sharp blade in your X-acto knife and spray glue makes construction easy, and metallic wrapping paper, ribbon and the beads from the broken necklace in the bottom of your jewelry box give the wise men exquisite robes. Or use acrylic paint instead. The figures can be much more abstract than the ones pictured, if you wish. Don't feel limited by three figures; place any number you wish marching up the aisle.

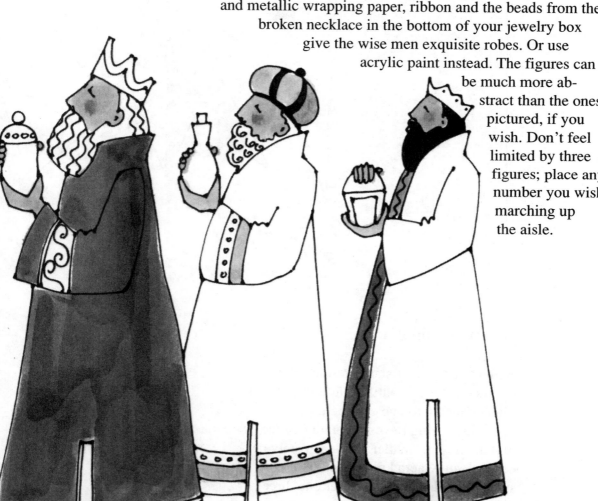

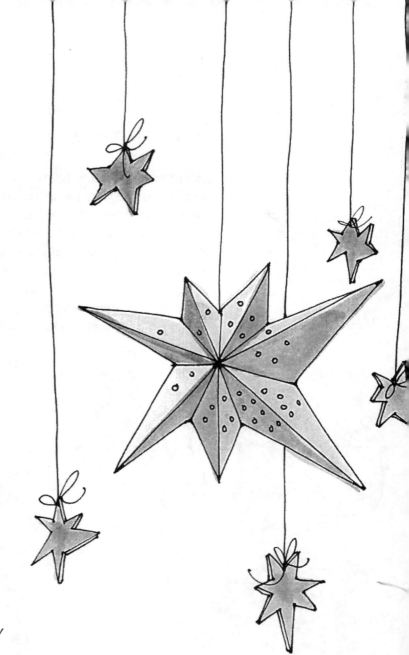

NIGHTTIME SKY

Hanging dozens of stars from the ceiling or rafters creates a beautiful nighttime sky and offers contrast to one elaborate star—the one symbolizing the one that guided the wise men. The smaller stars can easily be cut with an X-acto knife from foam core sprayed gold. Make the larger one three dimensional from heavy paper with holes punched in and a light inside. You will find a pattern for enlarging on the next page.

Imagine a star that can lead you to
"rejoice with exceeding joy" (Matthew 2:10)
when you arrive at the presence of the Christ
Child. The paper section of your local art
supply store with a wide variety of decorated
papers will offer inspiration for this project.

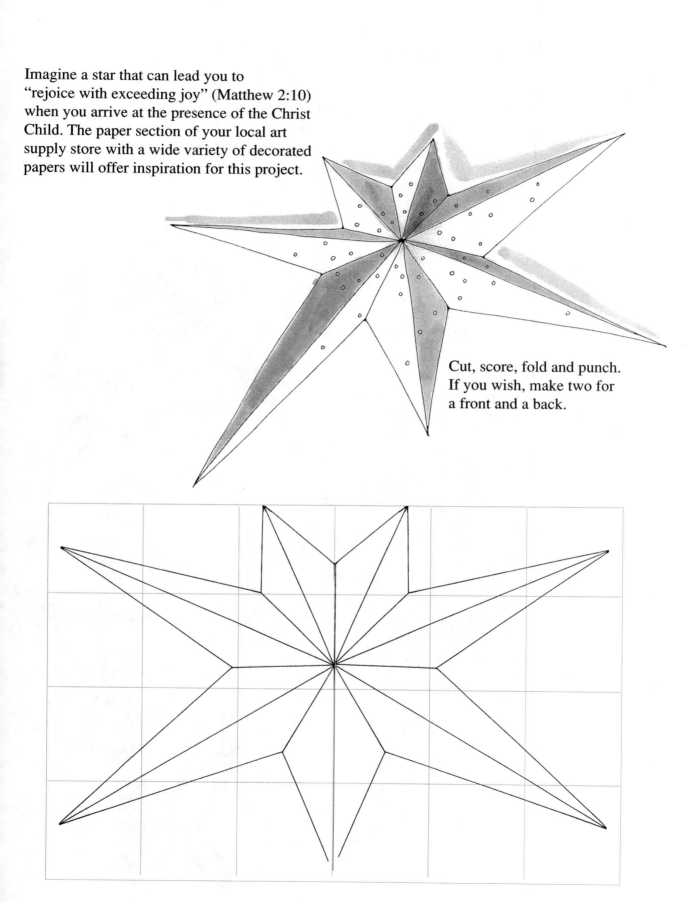

Cut, score, fold and punch.
If you wish, make two for
a front and a back.

TRANSFIGURATION

The Transfiguration story (Matthew 17, Mark 9 and Luke 9) is another highlight for the Epiphany season. Consider the Old Testament texts: Exodus 24, 2 Kings 2 and Deuteronomy 34. Discover together how you could create a breathtaking, mountaintop experience of dazzling brilliance, an awesome vision of God. What materials, designs and lights could you use?

GLISTENING MOSAIC

One possibility is to create a large (6-8 ft. high) mosaic of Jesus using foil art paper. Use a sheet of black foam core to give contrast to silver, gold, copper, green, red and blue pieces of foil. Create the figure of Jesus by gluing on various shapes and sizes of foil. Add pieces of mirror cut with a glass cutter. Think about how this bright mosaic could be lighted to get the full reflective effect.

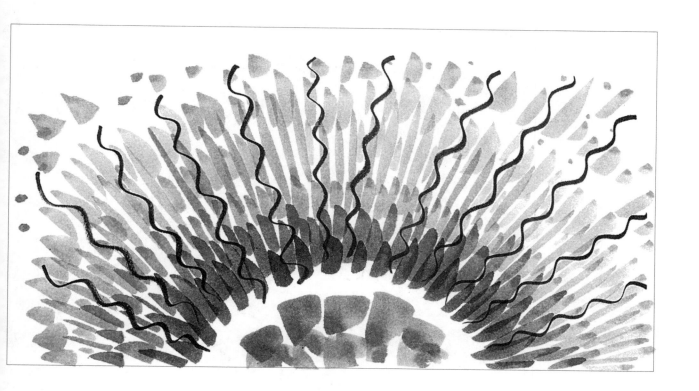

MOUNTAINTOP EXPERIENCE

Another Transfiguration idea is to create a less representational design, covering foam core or a large hemmed piece of canvas with short paint strokes and bright metallic paints, giving a sunrise-on-the-mountaintop feel. (Or use the top two quarters of the year-round/Easter wall hanging on page 42 for a sunrise effect.) If you add the three figures to the center of the canvas, painted in black, they represent Peter, James and John witnessing the Transfiguration; or in white, they depict Jesus, Moses and Elijah. For Easter, the same wall hanging could show the women at the tomb. If you make the figures detachable, the background will work in several seasons. Look carefully at the chancel area to find the most effective place for your work of art.

LENT

The somberness of Lent presents a stunning contrast to the celebration and brilliant colors of Epiphany. Read again the remarkable story in the last chapters of the Gospels of Matthew, Mark, Luke and John, and consider the mood and words of Lent:

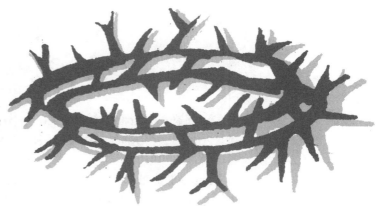

sorrow
grief
pain
struggle
bearing the burden/carrying the cross
traveling through a wilderness
sin—separation from God
consequence of sin
payment for a debt
willingness to pay the ultimate price
reality of death
cry for help
darkness
forsaken
alone
quaking earth
quaking hearts
cruelty
sacrifice
rescue and relief
love and grace of God
ultimate power of God
witness the crucifixion
salvation
completion
temptation
seeds and weeds
Satan
bread alone

What are *your* word associations and images for Lent?

Lent is an intentional journey beginning with Ash Wednesday. Lent is a reluctant walk because we have to face sin, agony and death. Holy Week is a week some would rather skip, going right to Easter. The art for Lent needs to capture feelings and help people experience the struggle with evil and darkness. The colors for Lent are earth colors: brown, gray and black; pain colors: red and orange; and the traditional liturgical color of purple. The textures are wood, stone, rough cloth or paper, ashes, and sharp thorns and nails.

SHROVE TUESDAY

FAMILY NIGHT PANCAKE SUPPER and BANNER MAKING

Shrove Tuesday is an ideal time for church members to gather for pancakes, sausages and community banner making. Long, narrow fabric backgrounds for banners, spread out on tables, allow many hands to contribute at once, and both children and adults can add their creative ideas. The tradition of *burying alleluias* during Lent makes this day perfect for constructing Easter's alleluia banners as well as Lent's somber ones. The banners pictured here and on the next page are ones that members at St. Peter Lutheran Church in Mishawaka, Indiana, have made during some of their Family Night events. The tall, narrow banners with Lenten colors and Lenten symbols are hung for Ash Wednesday the following day, and an Easter banner is rolled up tightly and tied with a purple cord at the top of each Lenten banner. Six weeks later, during the Easter Vigil at the singing of the *Gloria*, the cords are pulled and the bright new Easter banners come crashing down, loudly and colorfully proclaiming, "ALLELUIA!"

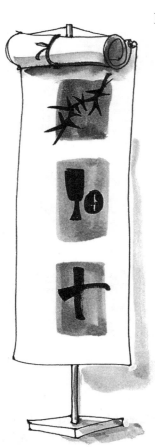

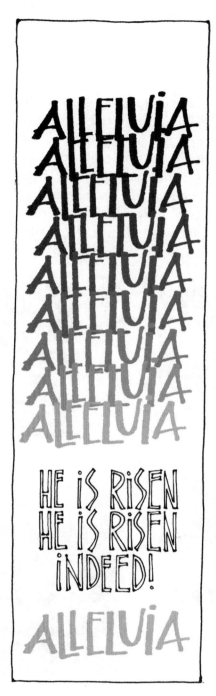

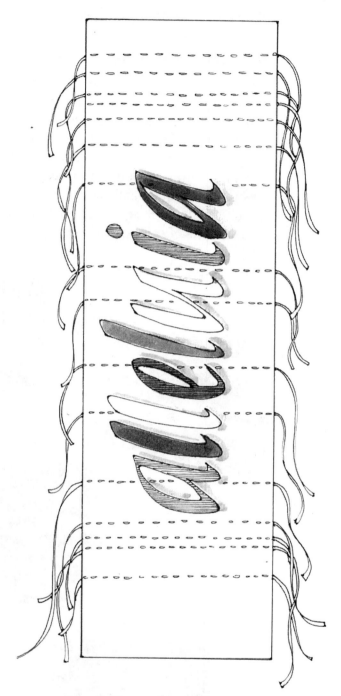

Shades and tints of pastel colors, moving from dark values to light, bring the overlapping *alleluias* to the fore.

Lots of hands at once—young and old—can add the woven ribbons for the celebratory effect of this banner. For the banner background use a loosely woven drapery fabric, then with narrow ribbons attached to safety pins or paper clips, weave the ribbons through. More can be added each year.

Shrove Tuesday continued...

CREATIVE CROSSES

While some folks work on banners, others may use their creativity constructing crosses. On a table or two spread out squares and scraps of felt in white and rich Lenten colors. Provide lots of scissors and glue (Tacky Glue is best), and invite everyone to create crosses that can adorn sanctuary walls during Lent. Designs for crosses can take many beautiful forms, so before cutting and gluing begin, someone might show examples of designs using quadrants and patterns of four. If you cut out the background squares ahead of time (or buy felt squares ready-cut), your sanctuary art will have uniformity in size and still lots of originality in design. You might want to use the idea that is described on page 36.

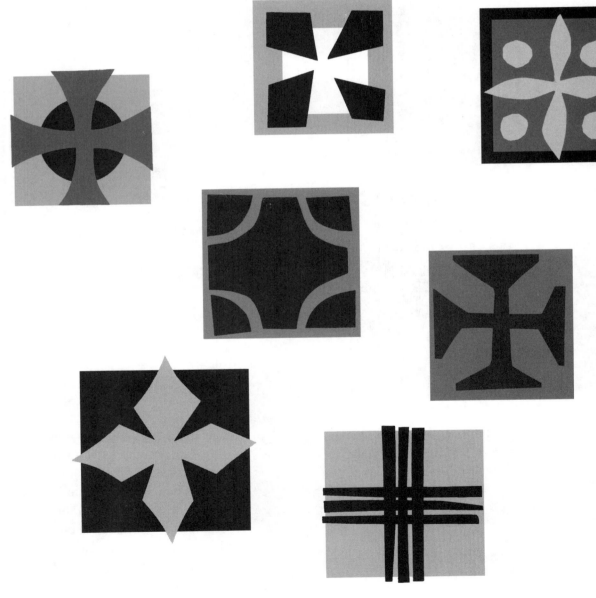

ALTAR CLOTH of ASHES

The beginning of the journey, Ash Wednesday, deserves special attention. Replace the fine purple altar frontal parament with burlap or other natural, rough fabric. With charcoal, ashes (mixture of leaf ashes and olive oil) or paint, paint a rough cross in the middle. As the worshipers receive ashes on their foreheads as signs of mortality and repentance, invite them to the altar to put their fingers in a dish of ashes and then imprint them on the altar hanging. If your congregation does not give ashes, these imprints can be done in advance.

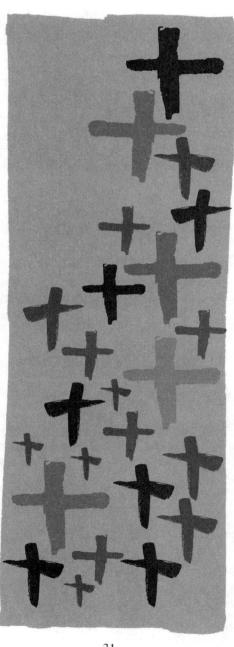

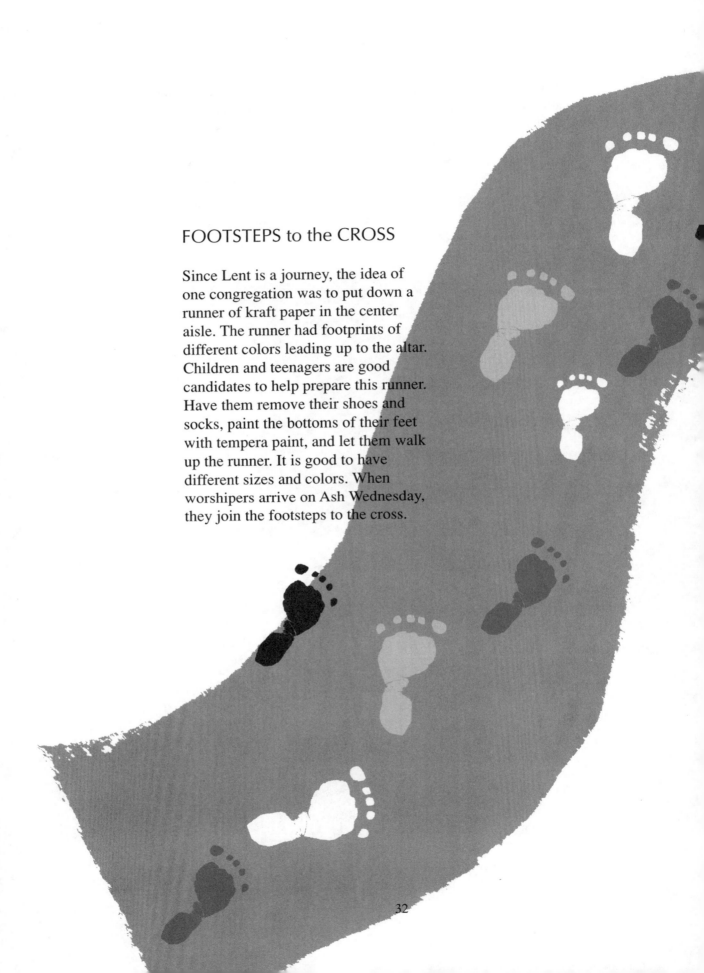

FOOTSTEPS to the CROSS

Since Lent is a journey, the idea of one congregation was to put down a runner of kraft paper in the center aisle. The runner had footprints of different colors leading up to the altar. Children and teenagers are good candidates to help prepare this runner. Have them remove their shoes and socks, paint the bottoms of their feet with tempera paint, and let them walk up the runner. It is good to have different sizes and colors. When worshipers arrive on Ash Wednesday, they join the footsteps to the cross.

CRUCIFIX

Even if your church has a crucifix prominently displayed, you might consider constructing an additional one this Lent. Using two 1" x 8" pine boards (or heavier if you like), an 8' cross can easily be nailed or screwed together, and some of your carpenters can make a stand for it. With acrylic paint in black and Lenten colors, add the head or figure of Christ. One of the most memorable faces of the dying Jesus I have seen had thorns; red and black deep spikes through his head; orange, burning eyes; a gray, dry open mouth; and sunken cheeks. The feeling was torture. At a Lutheran camp in New York state there is a large crucifix depicting the body of Jesus shown with protruding ribs, bulging stretched muscles, a gaping mouth and sunken eyes. Someone said to the artist, "I can't stand looking at it." The artist replied, "That's the point."

Another perspective on the cross is one done by a young artist in Lancaster, Pennsylvania. He chose a heavenly perspective of the cross, looking down from the top. There was the rough, brown cross piece, the bowed head of Jesus with a crown of thorns in black and red, and the stretched-out, long arms of Jesus with hands fastened by huge spikes. It was painted on a large piece of heavy paper, then cut out and glued on foam board to make it sturdy enough to hang above the altar. It is a startling image and caused us to think about what was happening in a different way. The art of Lent and Easter, depicting the death and resurrection of Christ, reminds us that these events move and direct our lives; Good Friday and Easter are the defining events of our faith.

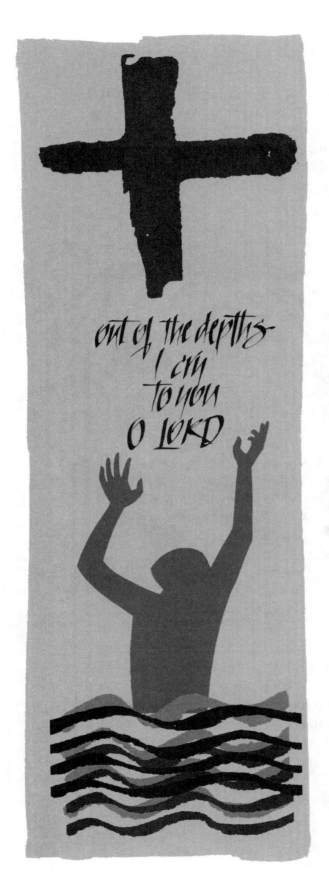

OUT of THE DEPTHS

We based a Lenten project at our church in Mt. Vernon on Psalm 130, "Out of the depths I cry to you, O Lord" (Psalm 30:1). On a 15' length of kraft paper we made a rubbing of a cross, using a purple paint stick and placing the paper over a rough piece of barn board. Reaching up to the cross was a silhouette of the upper portion of a person with long arms and large hands. The form was coming out of blue and purple "depths" of water made with pastel color sticks. Then we added the words of the Psalm, "Out of the depths." We placed this on the wall of the chancel arch, facing the congregation.

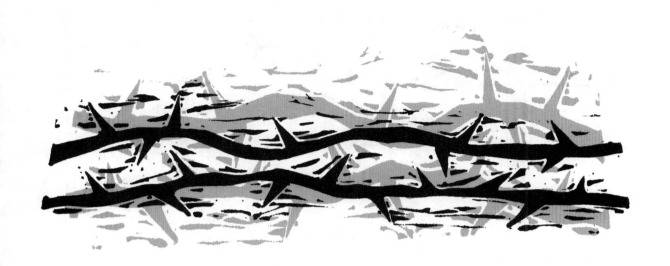

THORNS OVERHEAD

A church in St. Louis had the Lenten tradi-
tion of suspending a giant thorny branch
over the altar, hung with sturdy fishing line.
The image was a powerful reminder of
Jesus' suffering for us.

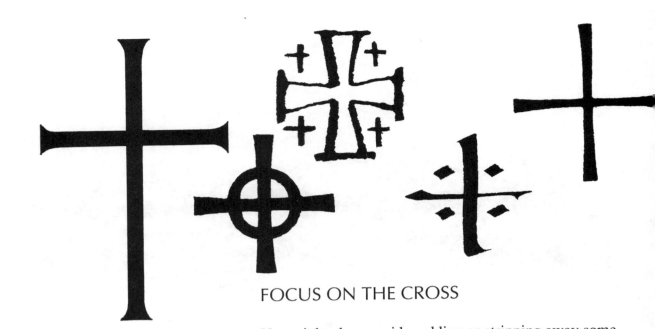

FOCUS ON THE CROSS

You might also consider adding or stripping away some-
thing of the work each week. One of the ideas we had
was to start with many types of crosses throughout the
church and remove some each week until we had only
one on Good Friday. Members can contribute family
crosses from home, or this can be done with the hand-
made felt crosses described on page 30. Families or
small groups might constuct crosses together, selecting a
space in the sanctuary and choosing their own materials.
In this way the crosses will fit the space and each will be
a unique expression of faith.

FROM DEATH to LIFE

This project could fill the chancel or the whole sanctuary with six
pairs of long, narrow fabric panels in shades of purple and lavender.
The first pair of deep purple or black banners is hung the first week in
Lent on freestanding banner stands on either side of the chancel area
or on the walls or beams on each side near the back of the sanctuary,
depending on your church's architecture. The second week a second
pair in a little lighter shade of purple is hung. Each week the violet
color lightens and the banners on each side get closer to the front or
the center of the chancel. On Easter a single, brilliant white banner is
hung, completing the progression of colors, signifying life out of
death.

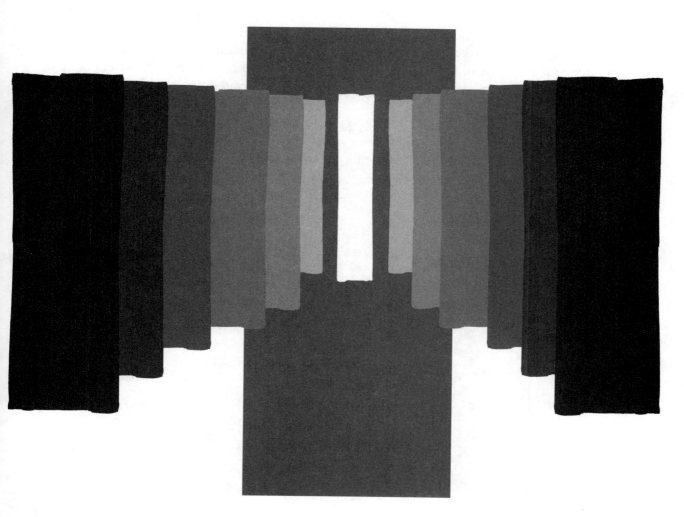

WAVING PALMS

Use a pointed brush and practice palm-type strokes by bending the brush bristles as you go down the stroke.

The variety of lightweight, sheer, translucent fabrics that lend themselves to fabric hangings also have paint possibilities. Experiment with watercolor and acrylic paints and a pointed brush and see what happens when you apply paint directly to nylon, organza, polyester organza, traditional cotton organdy and the very inexpensive nonwoven materials used for interfacing or for tracing patterns. (The nonwoven fabric doesn't even have to be hemmed.) Paint palm branches with various shades of greens and blues and turquoises until you get the effect you like. A dozen long, narrow banners that move easily and that are hung on each side of the nave or are carried into the sanctuary are a dramatic addition to your Palm Sunday procession and a fitting honor for the Lord's entry into Jerusalem.

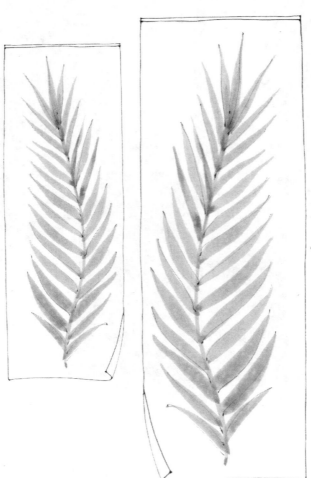
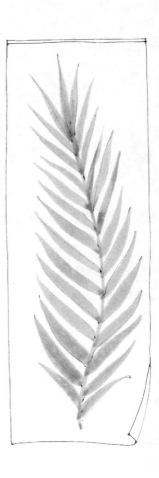

EASTER

Hallelujah! Christ is risen! Risen, indeed! Hallelujah! From the agony of Good Friday to the supreme joy of Easter, the contrast is astonishing. That astonishment and joy are a wonderful challenge for artists.

Message and moods of Easter:

light
hope
life now and life that's new
life after death
resurrection
empty, light-filled tomb
angels
"Mary"
garden in full bloom
grave clothes shed
joy
shouts of victory
ecstasy
morning
triumphant hymns
amazement
exhilaration
go and tell
breathless messengers—the women,
 Peter and John, us
walking with the Emmaus disciples
 and Jesus
heaven and earth are one (together again)

What else can you add?

Easter is dramatic and graphic. A cold, hard, stone tomb, sealed and guarded, dark and full of death becomes the open place of warmth, brightness, angels, life and the loving touch of Jesus.

Some of the many traditional symbols include sunrise, lilies, butterflies, Pascal candle and angels. A lily, a bulb that appears to be lifeless, is buried and then becomes a lovely, glistening, fragrant flower—a death to life image. A butterfly is similar. A creature crawls on its belly and then spins a cocoon (tomb) from which emerges a magnificent, airborne wonder.

BUTTERFLIES

Our group decided to use butterflies as our artistic expression of resurrection, life, transformation, beauty and joy. We were sure we could find a way to hang them from the eight overhead light fixtures and from the balcony. We decided they should be different sizes and different colors. We chose three sizes, 7" x 10", 8" x 11", and 12" x 17". Butterflies were cut out of heavy black paper. We used origami paper, foil paper, and bright, shiny paper to glue on the black wings. We made the colored wing pieces small enough to leave a half-inch border of black and glued them to each side of the butterfly. We made butterflies together with a lot of friendly chatter and color consultations. We tied black yarn to the top of each wing and made the lengths of the yarn two, three, four, five, six and seven feet. We hung six butterflies from each light fixture, each one at a different length, and myriads of butterflies from the balcony. They moved with the heat and the open door, and their bright, colorful, animated forms brought happiness to everyone. To add to the joyous festival, we tied white and yellow helium-filled balloons to the handrails that edged the outside steps.

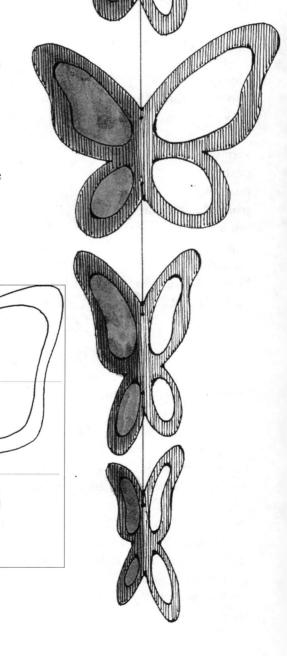

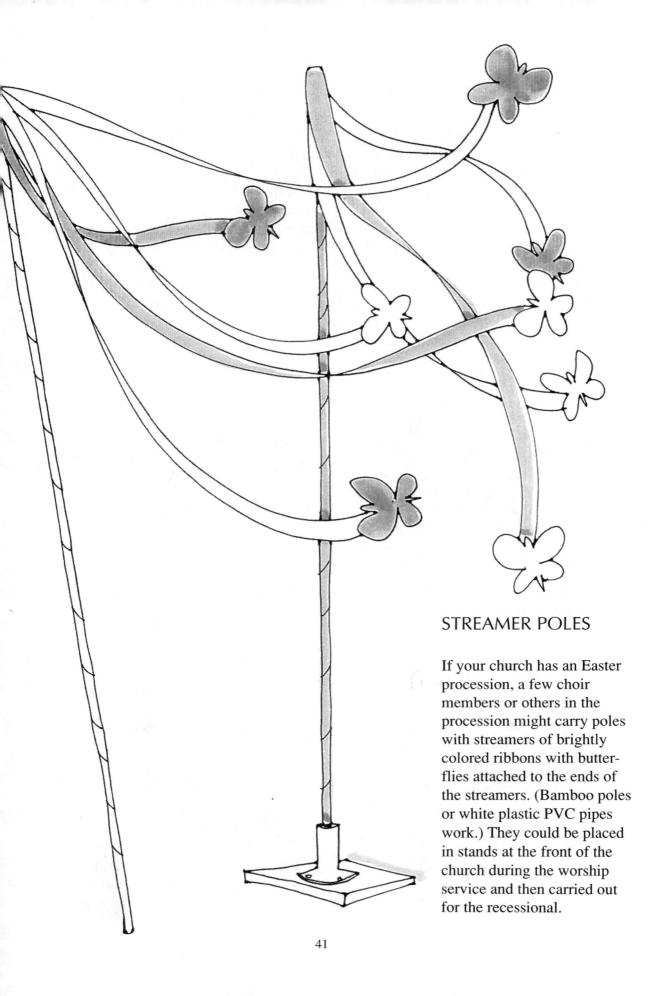

STREAMER POLES

If your church has an Easter procession, a few choir members or others in the procession might carry poles with streamers of brightly colored ribbons with butterflies attached to the ends of the streamers. (Bamboo poles or white plastic PVC pipes work.) They could be placed in stands at the front of the church during the worship service and then carried out for the recessional.

EASTER and ALL-YEAR-ROUND WALL HANGING

St. Peter Lutheran in Mishawaka created a giant circular wall hanging in quadrants, a beautiful Easter and year-round addition to their worship space. The hanging represents the entire church year with all of its liturgical colors. Each quarter of the hanging has a white background and features different liturgical colors in the outer area and a portion of the yellow and gold sunburst on the center part. Narrow fabric strips in various shades of green, purple, blue, red, orange and yellow were glued to the white backgrounds, and when the four quarters are arranged in a circle with space in between, they form a cross and a glorious Easter resurrection sunburst in the center. It makes a striking design on the enormous brick wall in their sanctuary. It's easy to attach it with Velcro to the bricks, and Velcro would work on plaster as well. (You can see a color variation of this on the cover of the book.)

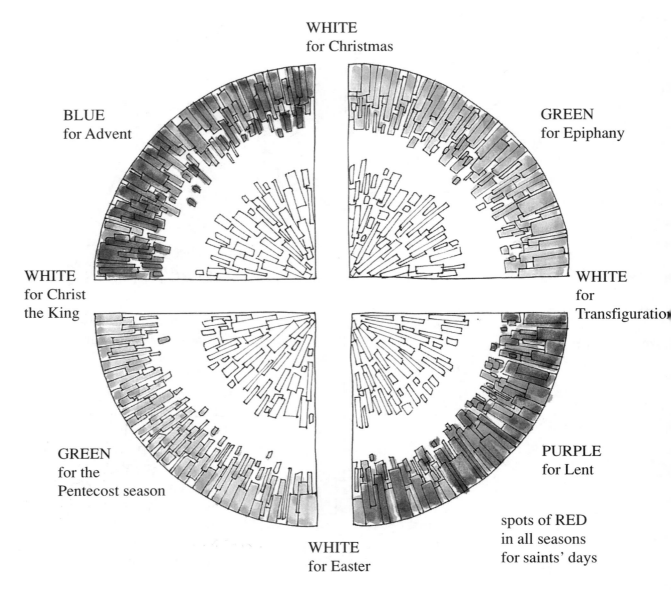

WHITE
for Christmas

BLUE
for Advent

GREEN
for Epiphany

WHITE
for Christ
the King

WHITE
for
Transfiguration

GREEN
for the
Pentecost season

PURPLE
for Lent

WHITE
for Easter

spots of RED
in all seasons
for saints' days

THE OPEN TOMB

A different Easter sunburst can be achieved on a large canvas covered with short strokes of acrylic paint all aimed toward the center point. Create a central area of bright white, yellow and gold, surrounded by progressively darker colors, signifying the view from the open tomb. The outlines of the women looking into the tomb might be added, "overexposed" by the brilliant light of Easter.

BUTTERFLY STABILE

Trinity Church in Brooklyn, New York, has a butterfly stabile for Easter, created by a member who is a sheet metal worker and artisan. He made it of found, cast-off sheet aluminum, steel pipe, a stand, this and that. When given a good push, the very large butterfly swings around its pole, adding movement and meaning to the Easter festivities.

A DRAPED SUNRISE

Advent Lutheran Church in New York City has beautiful windows on one side of the nave, and the other side is an enormous blank wall. Members artfully drape sheer fabric the length of the nave on this wall. Easter is bright with sunrise colors.

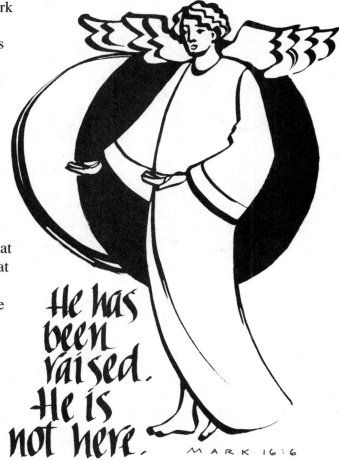

He has been raised. He is not here.
MARK 16:6

Think of other resurrection scenes that you can represent graphically and that convey the power of the Easter story—Jesus and Mary in front of the tomb, the angels and the women at the empty tomb, the disciples with Jesus on the road to Emmaus. They may inspire you to tell the story in another dramatic, graphic way.

The ASCENSION of JESUS

Ascension is not just a vanishing act by Jesus; it is about the presence of Jesus in every time and place. It has been a major church festival throughout Europe, and older Christians remember being confirmed on Ascension Day.

The first chapter of Acts tells us a cloud covered Jesus. That's an interesting vision. A cloud or mist watered the earth in the beginning, and Jesus, like the mist, covers the earth with life in God. I was considering how to fill the chancel with a cloud and thought about thin, nylon fabric or tissue paper. When I asked some Sunday school children how we could do it, one replied, "Balloons!" And I responded, "Yes!"

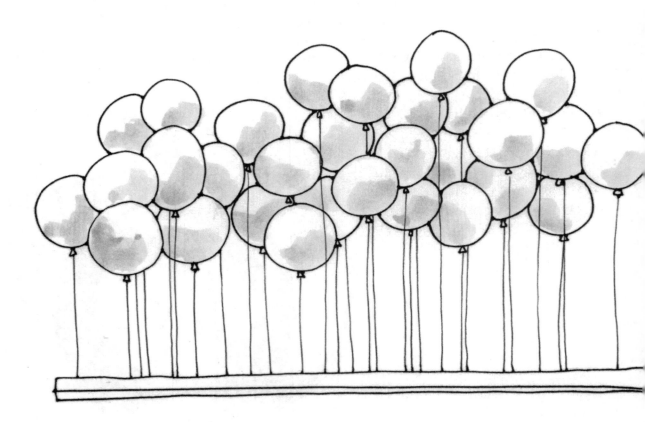

BALLOONING CLOUD

Create a huge cumulous cloud by tying white helium-filled balloons with white ribbons to a weight on the altar. It is easy to do in an hour and the best part is that each worshiper or family can take a balloon home to remember that the ascension of Jesus means that Jesus is always with them.

ASCENDING DANCE

Imagine standing with the disciples and looking up at Jesus ascending to the Father. Some artists show only Jesus' feet, some show a top view as God the Father would see, and one of my favorites by an Indonesian artist depicts Christ ascending in a beautiful dancing posture. Place a large piece of canvas (canvas is fairly inexpensive at the fabric store) on the floor with plenty of newspapers underneath and all around. Ask several church members if they have a few old cans of Latex paint at home in pastel colors. Thin each color with water and, using large paint brushes, use those pale pinks and yellows and blues to create a cloud-filled sky on the canvas. But don't paint "clouds." Instead, let the colors bleed into each other in giant swirls. When that dries, paint a very simple, abstract dancing, victorious figure (like the one pictured) of the ascending Christ on top of the pastel background. Is it possible to mount the canvas on a dowel, attach pulleys to a beam in the front of the sanctuary and raise it during the worship service?

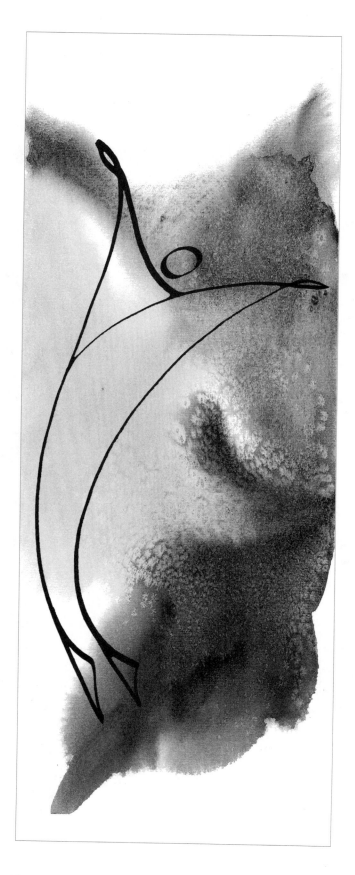

PENTECOST

Pentecost offers another dramatic opportunity for artists. The story of the Day of Pentecost in the second chapter of the Acts of the Apostles is a wild one. It is about being overwhelmed by the Holy Spirit and given the Spirit's energy and ability to do great things by faith. Read the second chapter in the Book of Acts, and list some of the words, emotions and messages of Pentecost:

wild wind
flames
tongues of fire
whooshing
loud noise
confusion
loud voices
strange, foreign words
crowds of people
different peoples, cultures, experiences
boldness, courage
surprise, excitement, amazement
3,000 added
HOLY SPIRIT
Spirit-filled
energy
strong storytelling
powerful preaching
understanding
conversion
call to repentance, faith and discipleship
Baptism
radical life change
birth and rebirth of the community of faith
happy birthday, Christian Church
fellowship
community

BALLOONS, FLAMES and DOVES

We wanted to surprise people as they came to church on Pentecost. First, we decided on the usual party idea and had red balloons flying from the wrought iron fence around the church.

We attached wide red ribbon to felt doves and hung them from the balcony.

We cut flames from neon-red poster board and attached them to the pews down the center aisle. Each flame is one piece, folded at the bottom and glued at the top.

SPIRIT ENERGY HAPPENING

Pentecost is daring, just like our next idea. We bought a bolt of sheer red fabric and cut strips 10" wide and 60 FEET long (or more if required). We draped them across the top of the sanctuary from pillar to post in a random fashion that says God's wildness and energy is in this place. This work of art is a creation of the moment. You can plan and draw what you hope to achieve; however, the final arrangement is a performance, a happening.

MANY LANGUAGES

We wrapped the lectern and pulpit in red fabric and tied it together with white strips. On the strips we wrote the various languages of the congregation, community and world, along with the ancient Acts 2 languages. A group of women who live in the nearby Adult Care Community and who are worshipers with us, made large, realistic doves from felt. We placed them on the red fabric on the pulpit, at the top of each pillar and on the balcony frontal. On Sunday morning we added the red balloons in front of the church. We had asked everyone to wear something red, and everyone got into the joy of Pentecost.

TONGUES of FIRE

Parishioners at St. Peter in Mishawaka employ the brick wall again, this time for Pentecost. Short pieces of red and gold metallic ribbon, like tongues of fire, are easily hung at various head-heights around the nave by simply rubberbanding them to the protruding bricks. The entire congregation experiences the tongues of fire overhead and participates in the power, energy and motion in the birth of the Church, the excitement of God's people coming together. The congregation also fills the sanctuary with red geranium plants and then sends plants home with new members as a symbol to fill the community with the Holy Spirit's energy.

WIND SOCKS

Hang giant red wind socks with red, orange and yellow ribbon streamers from the rafters, open the windows and doors, and allow "a whoosh of holy breath" to move through the church, reminiscent of that first Pentecost. To make wind socks, shape coat hangers into circles and thread them through the top hems of fabric "tubes" (made of satin or metallic fabric.) Attach fishing line to the coat hangers and long ribbon streamers to the other end of the "tube."

THE DAY of HOLY TRINITY,
AND
THE SUNDAYS
AFTER PENTECOST
OR
ORDINARY TIME

Trinity is a day of mystery and majesty: God the incomparable, wholly other, yet with us, the center of our universe, whom we worship.

Consider the names for God as ideas and feelings to present to the worshipers.

Creator
Redeemer
Sanctifier
I Am
Voice
Father
Savior
Holy Spirit
Friend
Wisdom
Word
King
Priest
Jesus
Messiah, Christ
Rock
Water
Bread
Shepherd, Gate
Light
Love
Vine
Peace
Immanuel
Holy Breath

Descriptive words for God:

merciful
gracious
healing
powerful
just
mediator
giver of abundant blessings
glorious
mighty
honor
nurturing, caring

Words for the long green season:

learning
hearing
doing
growing
listening
community
warm
wet
evenings
sunlight
down time
refreshment
time off
stories
miracles
retreat
a quiet place
vine, pruning, new growth
seed

Trinity Sunday begins the long season of Pentecost or Ordinary Time and ends with the glorious Christ the King Sunday at the end of autumn, signifying the end of the church year. These two bracketing Sundays have a similar feel of the majesty and mystery of God. During the Pentecost season we hear the many Scripture stories and readings that help us know God and center our lives on his Son. Think of ways to picture the many faces, facets, work, emotions and Word of God.

Consider creating a Trinity/Pentecost Tree. We are used to trees in the sanctuary already—Christmas trees, the wooden cross, palms in pots—so what about a Tree of Life? A tree that grows right there in your sanctuary, bearing witness to the life of God and the life of the people of God.

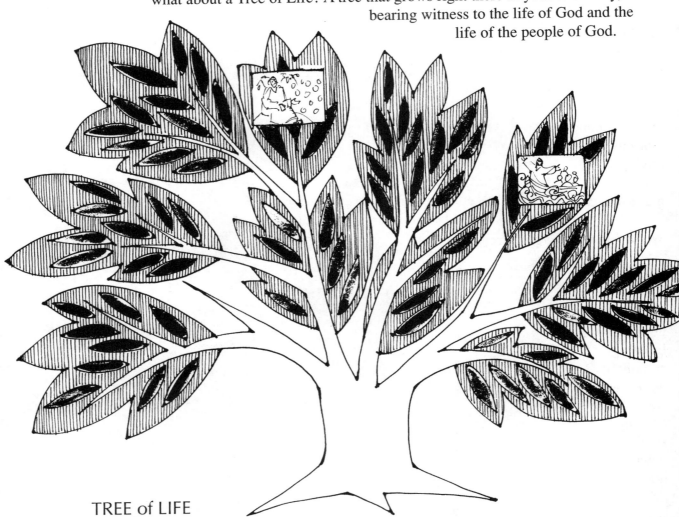

TREE of LIFE

We molded green chicken wire to form the tree trunk and branches. It looked good, but we wanted to place all the names for God we could think of on the trunk, so we added papier-maché and glued labels to the trunk with names of God. We fastened cardboard shapes to the branches so we could add paper clumps of leaves. The branches and leafy areas provided surfaces for artwork. Children and adults alike illustrated scenes from the Sunday Gospel readings, and we added them to the tree each week.

Depending on your space and surfaces, the tree can be flush with the wall or freestanding. It can have real branches or be made of fabric with appliqued and quilted branches and leaves. The tree could be cut from rolls of cork and fastened to the wall, providing a natural surface for hanging the illustrations. (Cork is available in 2' x 4' rolls.) Leaves can be paper, papier-maché or any other material your group dreams of. Read the stories and teachings of Jesus found in the Sunday Gospel lessons for this season, and pick out sections that speak to you or that spark creative ideas. Add these graphics to your tree during this green, growing season.

The Gospel lessons tell the stories of Jesus healing, feeding, choosing followers, protecting, telling parables and being in the middle of crowds of people. The psalms speak of God as rock, fortress, shield, defender and loving listener. The second readings speak of faith and the Christian life. You may want to look at the prayers of the day and hymns for other ideas for filling the branches with the good things from God. Various small groups or individuals can take different readings and add their graphic work to the tree. This is a perfect opportunity to incorporate vacation Bible school or your summer Sunday school into worship with the children's artwork. For Christ the King Sunday, the last Sunday of the church year, we placed the figure of Christ at the top of our tree and used metallic paper for the crown and robe. By now we had a wonderful tree, full of life, new adventures and a different way to see God.

There are numerous ways to depict the various stories from the season's Scripture readings:

THE KINGDOM of HEAVEN IS LIKE...

CHRIST the KING SUNDAY

The last Sunday of the church year is rich in imagery for artists, and the letter forms of Alpha and Omega, the first and last letters in the Greek alphabet, are two of the most beautiful ones—or rather, *one* of the most beautiful ones. Signifying Christ-who-is-and-who-was-and-who-is-to-come, the letters usually appear as one unit and can be joined, overlapped or superimposed in countless ways. Experiment with them, doodle around them, consider the counter spaces (the negative spaces of letters), think about infinity in both directions of time, and see what your lines and angles look like. If you wish, use this design as an appliqued wall hanging. Using bright colors of felt, glue or machine-stitch the pieces in place, then go back with gold fabric paint and embellish the forms with fine lines. It makes a beautiful altar piece or pulpit parament.

ST. MICHAEL AND ALL ANGELS DAY

September 29

ANGEL ANGLES

The beautiful, gentle s-curves on angel wings are a natural attraction to creative minds, and sheer, translucent fabrics complement the mystical qualities of angels. It's a winning combination! Using the simple nine pattern pieces shown here, numerous angel postures can be created. Try experimenting with white fabrics on top of white fabrics—organdy, various organzas, nonwoven interfacings, each with a different opacity. The pieces don't need to be hemmed or even treated for fraying. Simply cut them out, arrange them on a sheer background fabric, pin and attach them with a running stitch by hand. (Large areas like the gowns might need a few lines of stitching up the centers to hold them securely.) If you keep the panels the same width as the fabric, the selvages can serve as the side hems. The banners can be embellished with gold thread, beads, sequins or white acrylic paint, but don't let them get too heavy. Their lightweight translucent quality allows them to move with the slightest air movement in your sanctuary. Be aware of what will be behind these banners. The subtle differences in translucence will be evident when a dark color is behind them or when lighting is behind. A light-colored wall, however, obscures the design. The designs on the next page, as well as all the combinations of shapes you can design, could also, of course, become the host of Christmas angels.

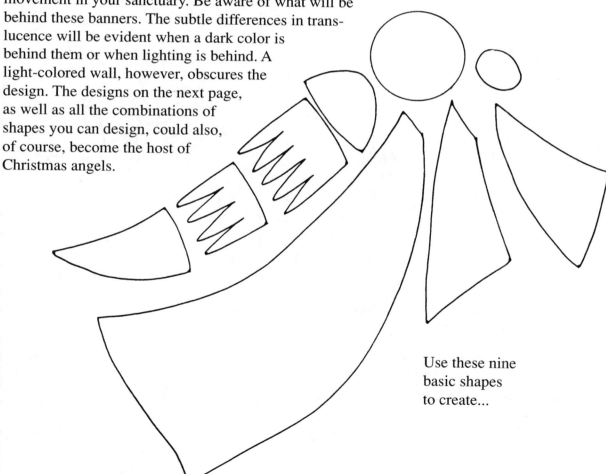

Use these nine
basic shapes
to create...

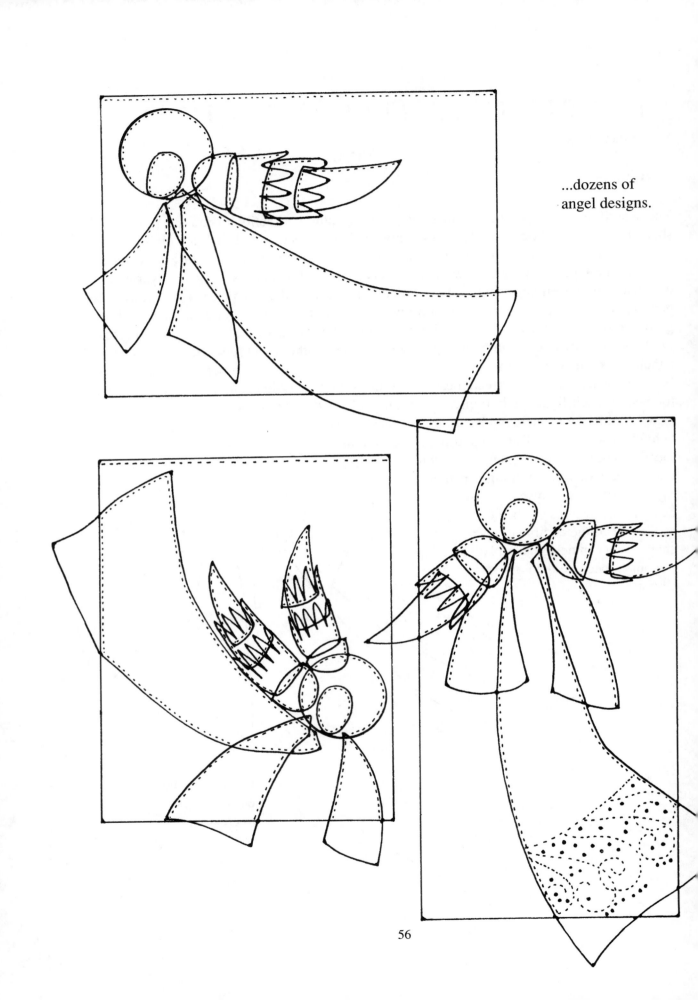

...dozens of
angel designs.

56

ALL SAINTS DAY

November 1

Read Revelation 21-22 and Isaiah 26, list all the glorious images, and let your pencil draw freely some of those visions.

VISION of HEAVEN

A large sheet of Plexi-glass or acrylic offers creative possibilities for All Saints' Day. The transparency of Plexi-glass invites us to see beyond, into a heavenly vision and joyful communion—a foretaste of that feast. Choose an image (saints in their brilliant robes, the new Jerusalem, brilliant light, the river of life or any other heavenly image), then think of ways to place that image on the Plexiglas. Three ideas follow: one easy, one medium, one difficult. EASY: Cut stencils from medium-weight paper and, using white spray paint, spray the cutout areas with a light coating. Allow some shapes to receive a heavier coating so your end result has a variety of "whites" and yet still has much transparency. MEDIUM: Enlarge the pattern to fit your Plexi-glass, place it under the Plexi-glass, and, using an etching tool (a nail will work, too), inscribe lines in a shaded, cross-hatched manner right onto the plastic surface. Vary the closeness of your cross-hatching lines for a variety of translucence in the overall effect. DIFFICULT: Using an X-acto knife, cut a stencil out of rigid vinyl or mylar and tape it to the Plexi-glass. (All materials are available from a plastics supplier.) Using a sandblaster, etch the shapes into the Plexi-glass, allowing forms to overlap and some forms to be more opaque than others. Drill two holes in the top and suspend it over the altar, placing the heavenly vision in the line of every worshiper's gaze.

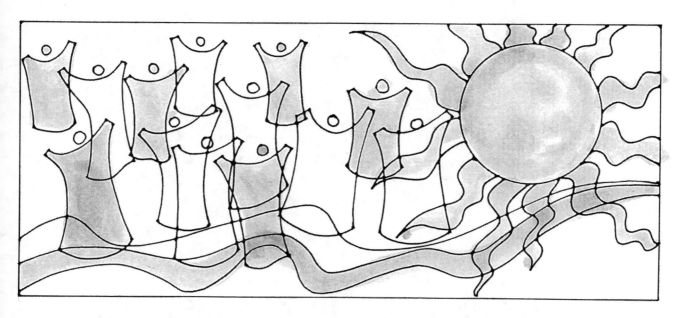

SAINTS on EARTH and THOSE ABOVE

This project needs full congregational participation—all the saints! Ask each member to bring in a scrap of fabric (at least 5" x 5") that is significant for them. And, if they wish, members can also bring fabric scraps that remind them of a friend or family member who has died. Use the pattern piece shown on the next page (or, better, design your own people-silhouettes in all shapes and sizes), and cut each fabric piece into a human figure shape. Glue them to a giant wreath of foam core or sew them with a loose running stitch to a large, square fabric panel. They can be arranged in random patchwork or grouped into blocks of similar colors. If the quilters in your congregation are willing, the figures could be quilted instead, appliqued and outlined with a "crazy quilt" stitch. Place a symbol for the Lamb in the center: a Chi Rho, a Jerusalem cross, a chalice with bread, or a lamb, with the whole composition signifying the gathering of the saints, *us*, around our Lord on the throne. By grace we are saints!

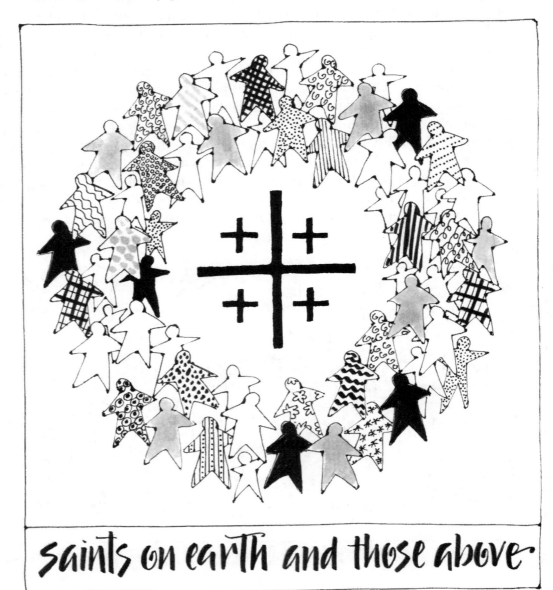

saints on earth and those above

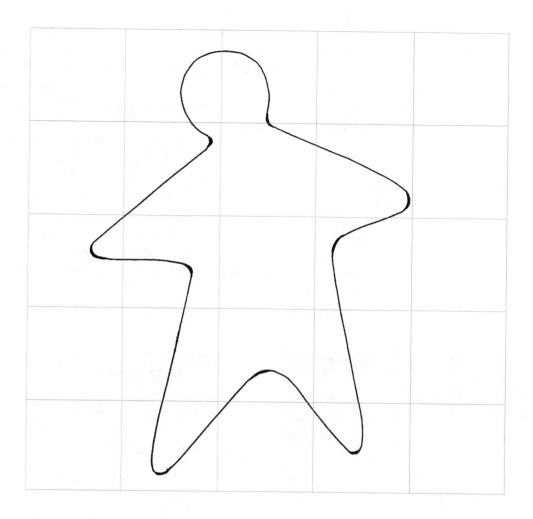

If you wait until the All Saints' Day worship service to assemble the banner, everyone can participate in the assembly. Perhaps during the processional, members could come forward in the sanctuary to attach their figures. (Velcro works!) But it doesn't have to be *final*, either; figures for new members and newly baptized babies can be added to the artwork regularly. And you may want to add your church's name as well.

St. John

December 27

St. Mark

April 25

St. Matthew

September 21

St. Luke

October 18

Highlight the four Gospel writers with large square canvases stretched onto wooden frames. (Someone at the art supply store can show you how easily canvas can be attached to canvas stretchers with a staple gun.) The winged creatures that represent these four saints are delightful forms for artists: St. John—the eagle with its piercing gaze that sees the mysteries of heaven; St. Luke—the winged ox signifying Christ's sacrificial life; St. Mark—the winged lion symbolizing Christ's royal dignity; St. Matthew—the divine man signifying Christ's human nature. Leave the canvas in its natural color and think about the various materials you could use for outlining the images—acrylic paint, fabric paint that's squeezed on and creates a "relief" surface design, or embroidery with black and gold floss or yarn. What else? Filling the busy backgrounds with rich colors of acrylic paint and letting the figures themselves remain the color of the canvas might be an effective way of focusing on the symbolic creatures. Each canvas could be displayed on its appropriate day, or they could be hung together all year round.

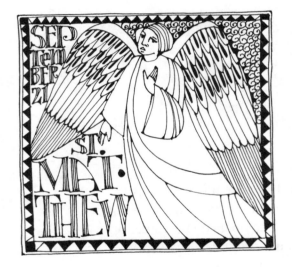

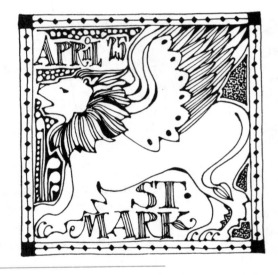

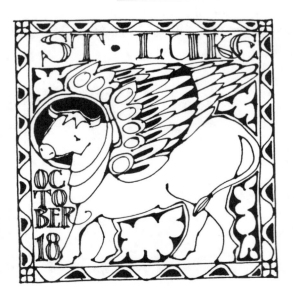

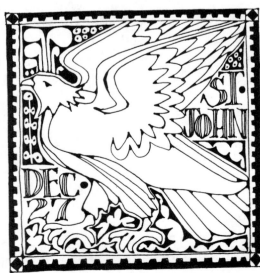

ALL THROUGH the YEAR

Many liturgical rites not associated with only one season also lend themselves to creative visual endeavors. The symbols and images of Baptism, for example, are wondrously inspirational.

BAPTISM WAVES

Being called by name and becoming a child of God in Baptism is a focal point in the life of the Church and the focal point of the Christian life. But where *is* your baptismal font? Does it have a place in your sanctuary that offers a frequent reminder of God's enormous grace? A graceful fabric hanging over it might serve that purpose, and an open basin with a constant source of water allows worshipers to dip their fingers in often, make the sign of the cross, and renew their baptisms. Could your baptismal font be moved to a prominent spot? A banner with simple waves in shades of blue and green hung above it might be a way to highlight it. Just like the banners painted on nylon organza for Palm Sunday, page 38, you might try painting with watercolors or acrylics directly onto the fabric. The resulting banner is nearly weightless and its see-through quality prevents it from interfering with other sanctuary decoration. Or perhaps the baptism banner might be brought out especially for baptisms or for monthly baptismal anniversary celebrations.

OR what if these simple shapes were cut out of mylar and hung with fishing line to form a mobile above the font?

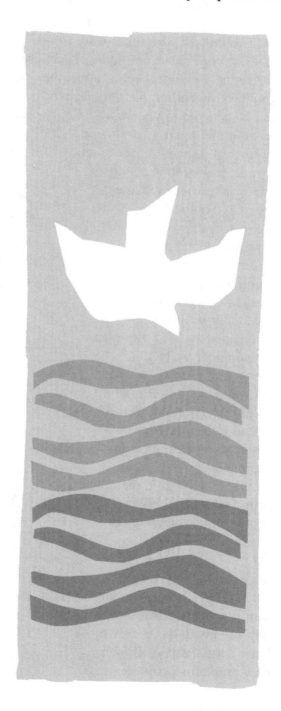

WALL TEXTS

Many older churches contain beautiful wall art in the form of lettering—echoing the exquisite, illuminated manuscripts from the Middle Ages. If your sanctuary has a more modern design, hand-lettered texts on the walls will still add striking and meaningful art. A Scripture text that is significant for your church's name or a line from the liturgy (from the *Te Deum*, for example) or a few verses from a psalm— each could add a spot of beauty to your worship space or, for that matter, any other place in your church building. There are a number of ways to go about this. If your parish has a calligrapher as a member, that person probably has wonderful ideas. If you have no calligrapher, the beautiful fonts available in many computer programs can be adapted to your walls. Choose a text, arrange an eye-pleasing composition on your computer, experiment with different typefaces and make a hard copy. Next, hand-feed a sheet of transparency film into your copier to produce a transparency to use with an overhead projector. Project the image on your wall using the overhead projector, and carefully pencil in an outline of the letters. Using small pointed watercolor brushes and latex paint, fill in the letters. Drips or mistakes can be cleaned up with a sponge. (Cleanups must be done quickly, of course.) Maybe you want to try illuminating (adding decoration to) the first letter, using your own design or something from computer clip art. Adding highlights with gold metallic paint and a small brush is another traditional way of illuminating letters. If you're not pleased with the result, it's easy to paint over the entire thing and start again. You'll probably become intrigued with the beauty of letter forms, especially when they proclaim Scripture, and you'll start eyeing every available surface.

If I take the wings of the morning and dwell in the uttermost parts of the sea, even there your hand will lead me and your right hand will hold me fast.

PSALM 139 : 8 - 9

RAINBOW WALL

Consider a whole wall of rainbow-colored fabric panels that do double duty as altar paraments. Six long, narrow solid color panels, each signifying a different season of the church year, become a rainbow wall hanging while taking turns as altar paraments for each season. Blue for Advent, purple for Lent, gold for Easter, red for Pentecost, green for Epiphany and the Sundays after Pentecost or Ordinary Time, and white for Christmas. The ones pictured here feature symbols for each season, too, but the hanging is striking in its simplicity without symbols, as well. Keep an open mind when you visit the fabric store, and consider a fabric that you've never used for banners before—maybe gabardine or rayon fabrics, which hang beautifully. Be sure to look at all the drapery fabrics, too.

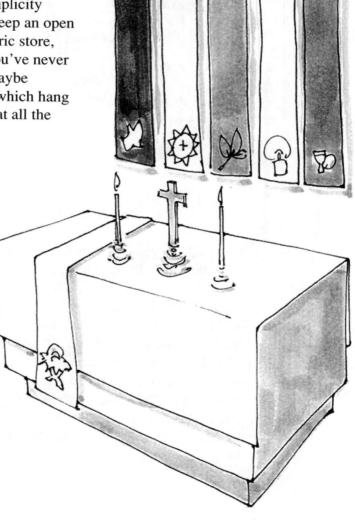

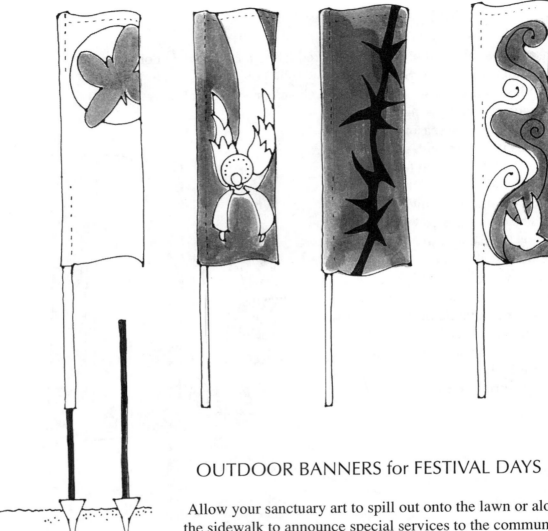

OUTDOOR BANNERS for FESTIVAL DAYS

Allow your sanctuary art to spill out onto the lawn or along the sidewalk to announce special services to the community and invite the neighbors in. The four-foot poles with pointed bases that are used for stringing electric fences can be purchased at feed stores or hardware stores and are easily pushed into the ground for displaying banners outdoors. Slide a tall metal hard-wall electrical conduit pole or a plastic PVC pipe over each one to hold your weatherproof nylon banners. Borrow ideas from the bright flags that housing developers fly to invite you to look at model homes, but use liturgical colors instead: blue for Advent; violet for Lent; gold or white for Easter, Ascension, Christ the King Sunday and Christmas; red for Pentecost. Solid white banners can announce weddings, too.

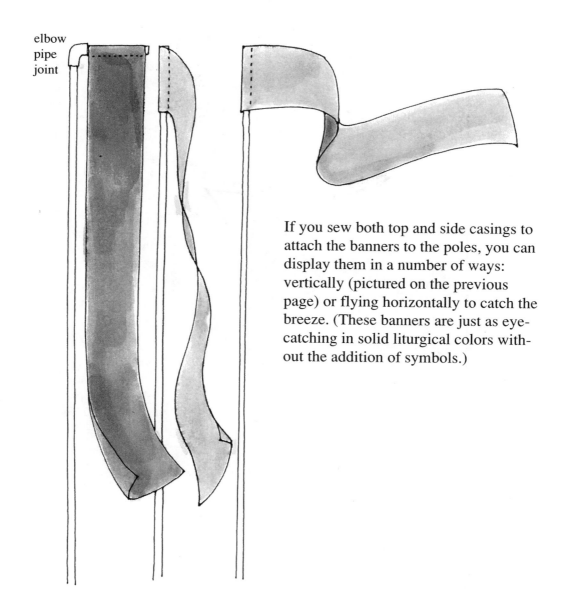

elbow
pipe
joint

If you sew both top and side casings to attach the banners to the poles, you can display them in a number of ways: vertically (pictured on the previous page) or flying horizontally to catch the breeze. (These banners are just as eye-catching in solid liturgical colors without the addition of symbols.)

CONSTRUCTION AIDS

BASIC STAND and PLATFORM
for banners
flowers
candles
torches

Here's an easy-to-assemble, adjustable stand that works for many different sanctuary purposes. Because each church's architecture and each group's creative thinking will require variations on this, just the basics are presented here.

CANDLE or FLOWER STAND

wooden platform

threaded steel plumber's flange

steel pipe that screws into the plumber's flange above and into the flange on the base below

BANNER STAND

banner poles fit down into the steel pipe

thumb screw holds banner poles securely and allows varying heights

(If the ends of the poles aren't already threaded, someone at the hardware store can make a threaded hole in the steel pipe for the thumb screw and also make threaded ends on the pipes so they can be screwed into the flanges.)

30" steel pipe

threaded steel plumber's flange

threaded steel plumber's flange

wooden platform

paint bases the color of flooring

ENLARGING DESIGNS

Creative people can use the designs in this book in numerous ways. It is the intention of the authors that you consider the ideas, use them and do something with them that makes them your own. If you wish to use the designs just as they are and need to enlarge them, three possibilities follow:

1. **Overhead Projector:** If you have an overhead projector available, it is easy to make a transparency of the design, project it on butcher paper taped to the wall and draw it any size you wish. Transparency film for overhead projectors is available at office supply stores, and you can make a transparency by hand-feeding the film into your copier and making a photocopy of the design on the film.

2. **Quick Print Services:** To enlarge a pattern, save time and eliminate frustration, use the services of a quick print copy company. Check the cost, and you may decide it makes sense to let someone else do the work. Yes, your designs can even be enlarged to 25 feet or more!

3. **Enlarging by Hand with a Grid:** If the pattern does not contain a lot of details, this method might be best. First, make a photocopy of the design. With a ruler, carefully draw grid lines across it. Decide how big your enlarged drawing will be, and cut butcher paper to that size. With a yardstick (a T-square is handy, too), draw a grid with the same number of squares on the butcher paper. Using a pencil, and keeping an eraser handy, draw the design on the butcher paper by eyeballing the lines, square by square, on the grid. This takes patience, but you'll be able to make adjustments as you draw and the result will be *yours*. See the diagram on the following page.

When you draw the grid lines on your large paper, make sure you have the same proportions; for example, in this enlargement, you need three squares across the top and seven down the side. It is essential that all the lines are equidistant so you have perfect squares. As you draw, refer back and forth from the design to your drawing, square by square. It's important that the grid lines are measured carefully, but it's not important to copy the image exactly. Be creative and add your own ideas.

GLOSSARY

Chancel Front area of the church with the altar, pulpit and lectern.

El Dia de Los Reyes The *Day of the Kings* (Spanish) is the celebration of Epiphany. For much of the world Epiphany is the major celebration of the birth of Jesus.

Foam core Foam core is a thick poster-type of art material. It is like a poster board sandwich. The middle layer is made of styrofoam.

Liturgical Refers to liturgy, the parts and order of the worship service, the rites associated with the sacraments and the celebrations of the seasons and festival days of the Christian church year.

Nave The large area of the sanctuary where the congregation sits.

Opaque Materials that do not allow light to shine through.

Papier-maché Literally paper mush. Molding of sculpting material made of strips or small pieces of newsprint dipped or mixed with a flour paste. Usually the narrow strips are dipped in paste and then molded around a form of wire, cardboard, etc.

Paraments The colored fabric hangings on the pulpit, lectern and altar that usually correspond in colors or symbols to the Christian church year.

Romanesque An Italian architecture style that features rounded elements. The arches are rounded, pillars are round, the chancel is rounded.

Stabile A sculpture, often one that has moving parts, that sits on the floor. Similar to a mobile that hangs from the ceilng.

Translucent Materials that allow light to shine through, like frosted glass or sheer fabrics. Forms can be seen through translucent materials but not as clearly as through transparent ones.

FINALLY

Y ou may want to preserve and repeat some of your works of art. A great part of the joy of adorning the sanctuary, however, is the present time. Your group of artists and decorators will change and bring new ideas and skills. Welders, carpenters, potters, weavers, quilters, painters, calligraphers, designers, sewers, printmakers—dreamers all—will bring visions to your worship space. Daily life, community and world events will change and, therefore, create different ideas and matters of faith to communicate and celebrate. There is something immediate, something "in the doing," that makes this wonderful, and the electric and loving spirit that exists in a small group expressing faith through art and design is the Spirit's doing. Creativity is a gift from the Holy Spirit, and gifts are meant to be used and enjoyed! When you are in the middle of a project, you may be wondering, "Is this work or is it play or is it worship?" The answer is, "Yes!" May the Spirit's holy breath continue to inspire you to fill your worship space with beauty, meaning and glory to God.

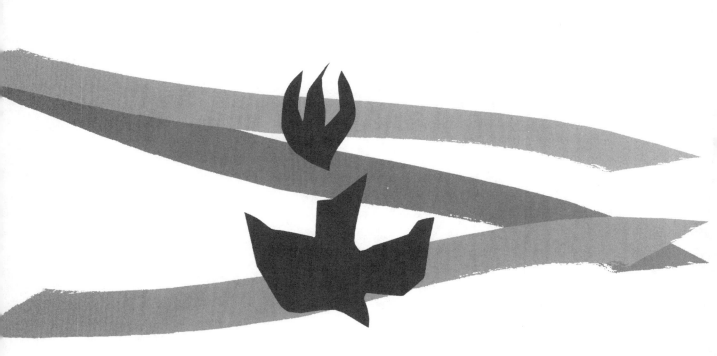